W9-BDU-137

THIS COMIC BOOK BELONGS TO:

nes lee

Blank Comic Book for Kids

© Blank Comic Book for Kids. All rights reserved. No part of this publication may be reproduced, distributed, or transmitted, in any form or by any means, including photocopying, recording, or other electronic or mechanical methods, without prior written permission of the publisher, except in the case of brief quotations embodied in critical reviews and certain other noncommercial uses permitted by copyright law.

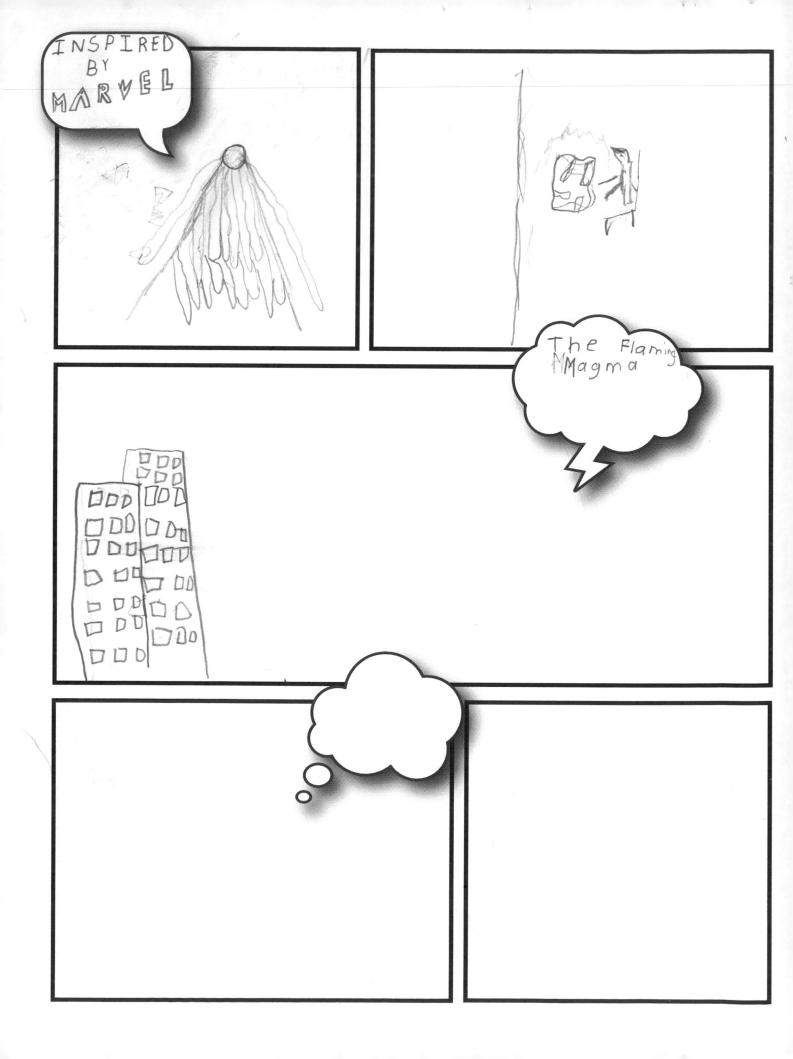

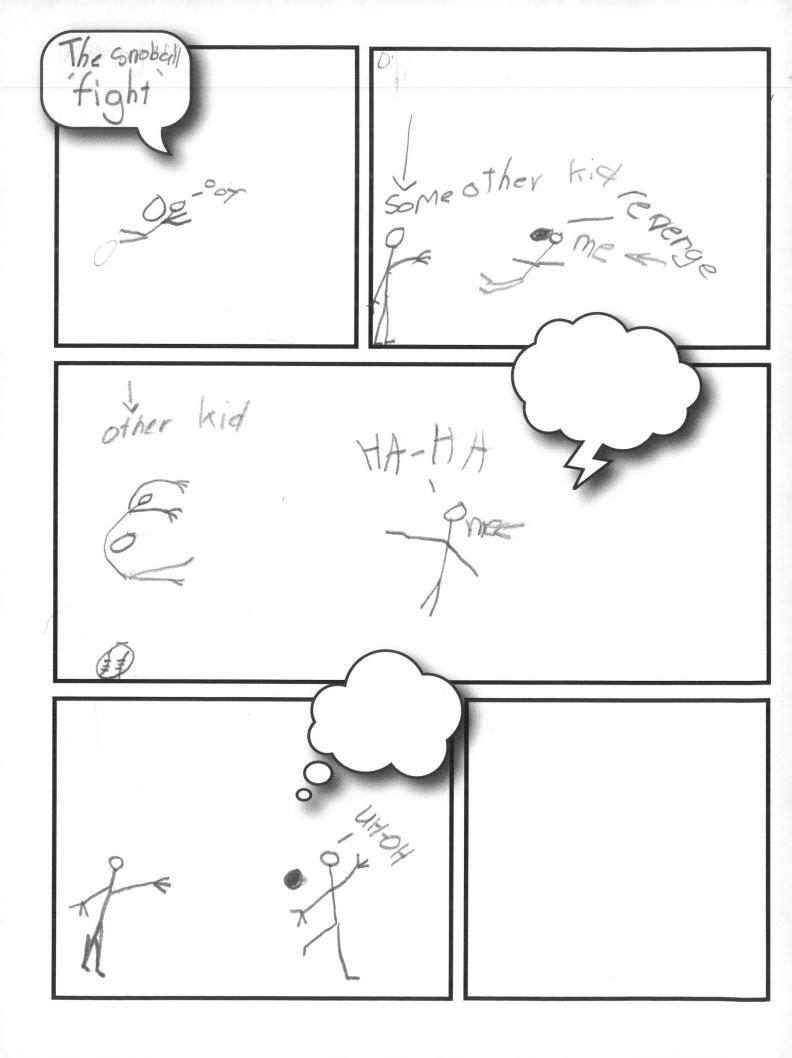

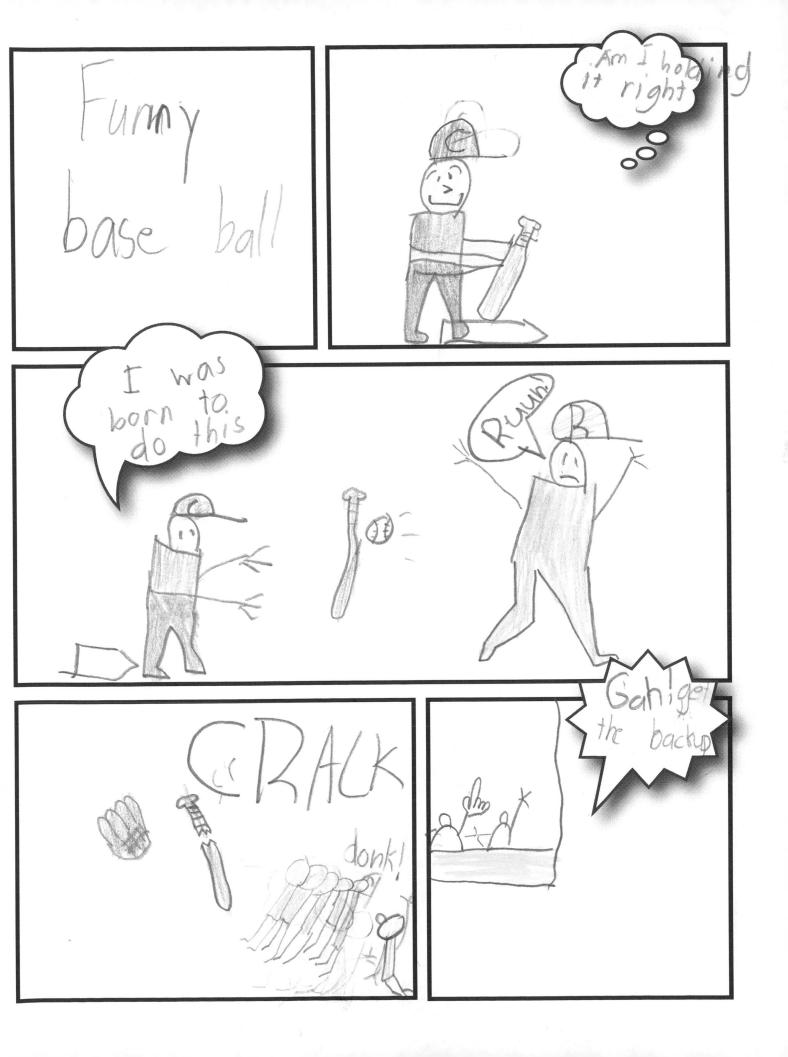

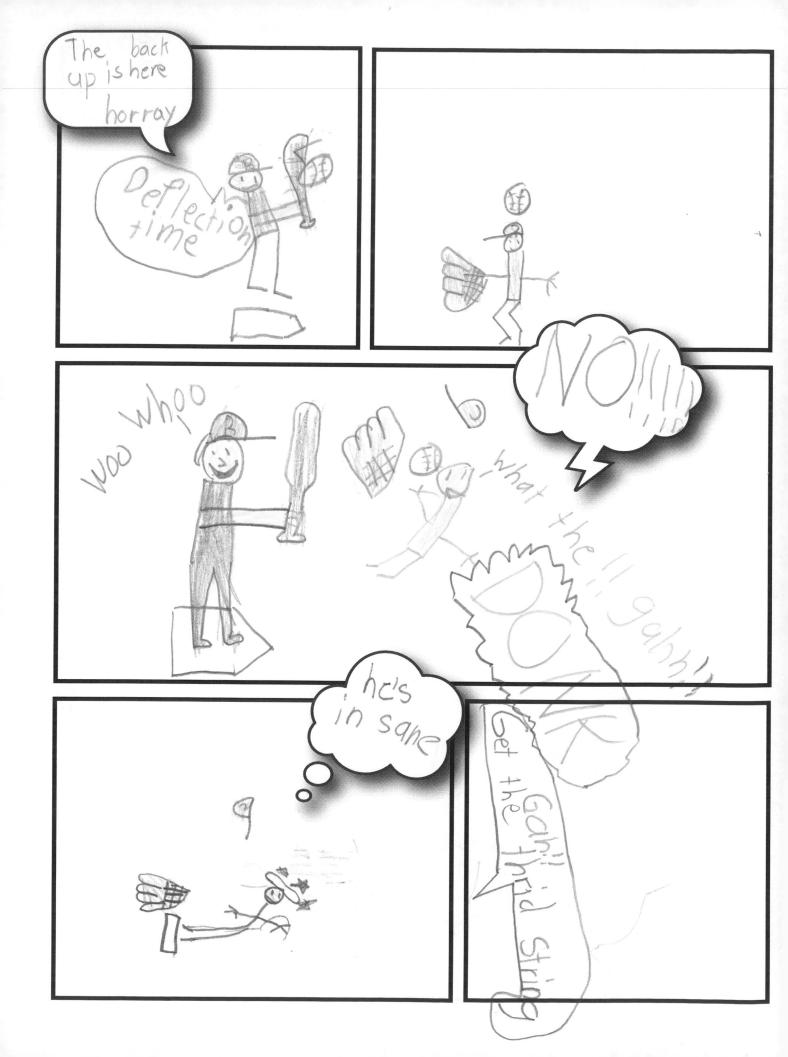

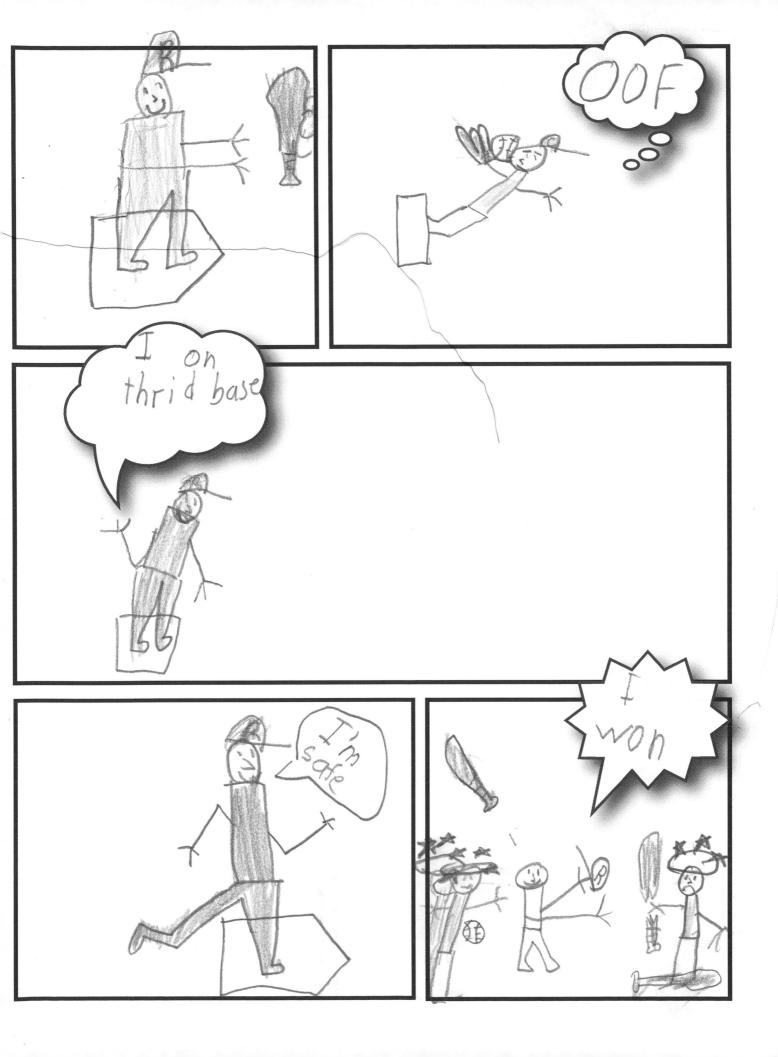